T0128402

VISIONS

II

PAINTINGS POETRY

MARGARET ELIZABETH BIGGS

Balboa Press books may be ordered through booksellers or by contacting:

Balboa Press
A Division of Hay House
1663 Liberty Drive
Bloomington, IN 47403
www.balboapress.com
1 (877) 407-4847

Because of the dynamic nature of the Internet, any web addresses or links contained in this book may have changed since publication and may no longer be valid. The views expressed in this work are solely those of the author and do not necessarily reflect the views of the publisher, and the publisher hereby disclaims any responsibility for them.

Any people depicted in stock imagery provided by Thinkstock are models, and such images are being used for illustrative purposes only.
Certain stock imagery © Thinkstock.

ISBN: 978-1-4525-8611-3 (sc)
ISBN: 978-1-4525-8610-6 (e)

Printed in the United States of America.

Balboa Press rev. date: 11/14/2013

BALBOA.
PRESS
A DIVISION OF HAY HOUSE

For Ruzica

Through countless challenges you have been a source of light to those who know you. Your classes and more importantly your actions, attitude, and peaceful presence are an inspiration to us all.

Agape,

Margo

Contents

Peace Like a River
And the river flows
To what glorious places
God only knows.

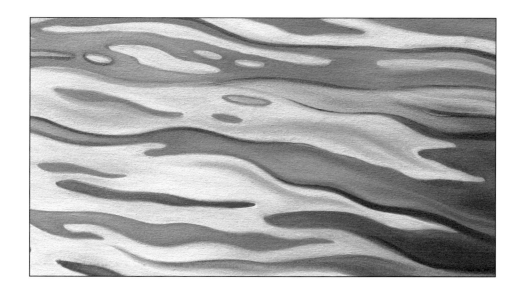

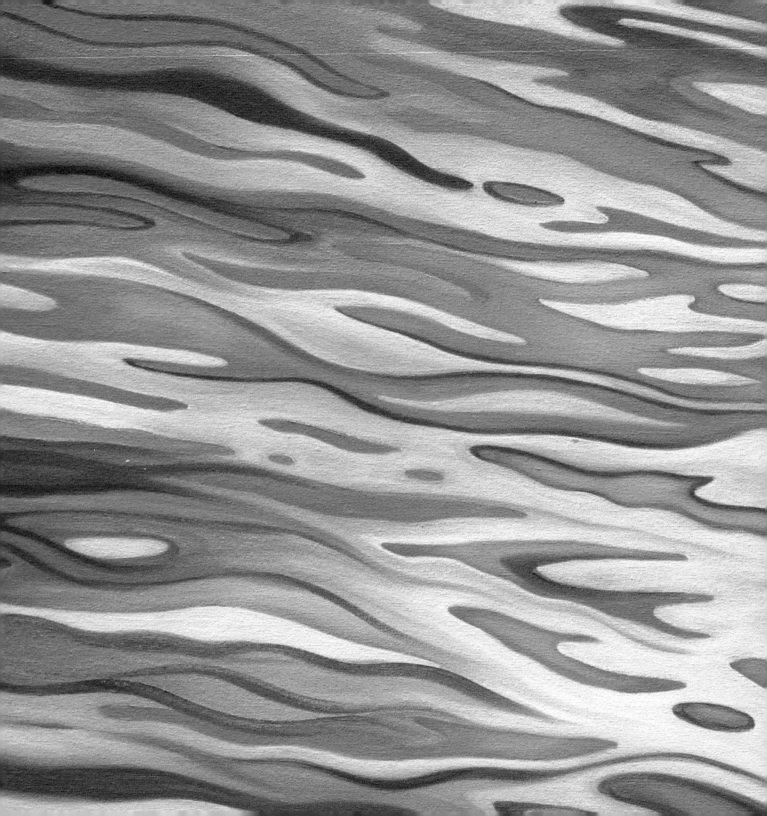

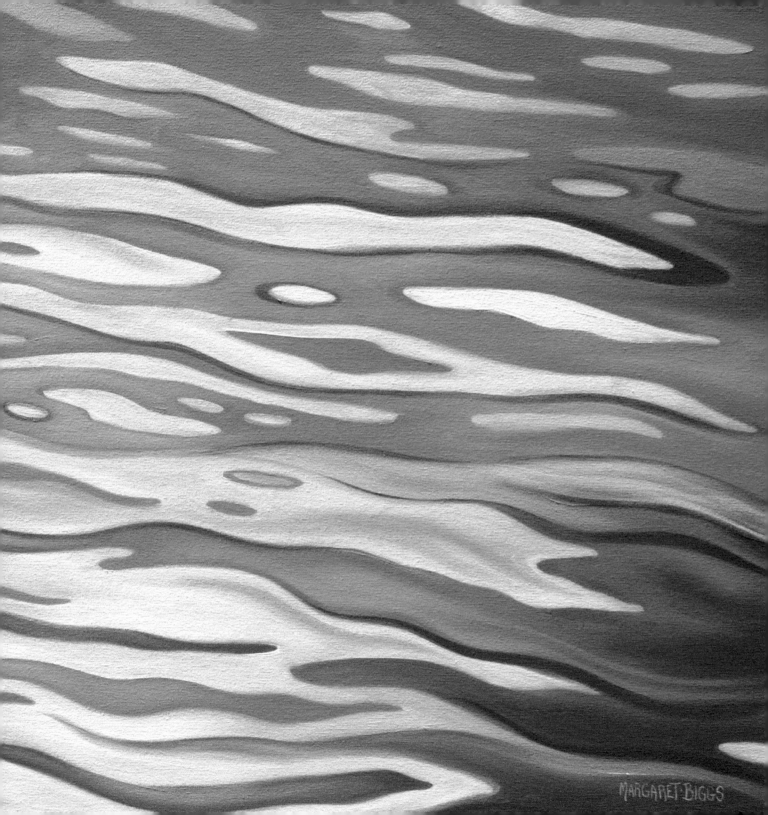

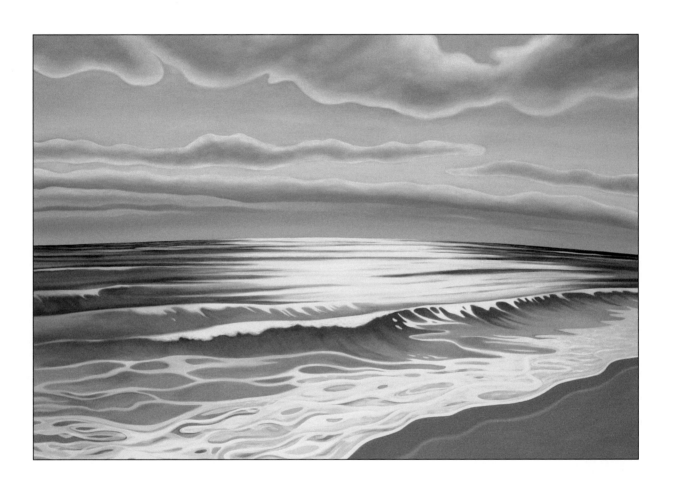

The Light of the Heavens
Break through the storm clouds
Shining through the dense darkness
A white light.

The reflections, an analogy of the seekers
Wishing, manifesting, willing.

The Light of the Heavens
Shining down through the darkness of thought
To the body which, so like our seas
Are many droplets, which make up One.

One ocean, one Body.
The penetration of Light
Through to the depths of thought.
The reflection of Light
Reaching back up to the Heavens.

A dissolution of darkness
The saving grace of our world.

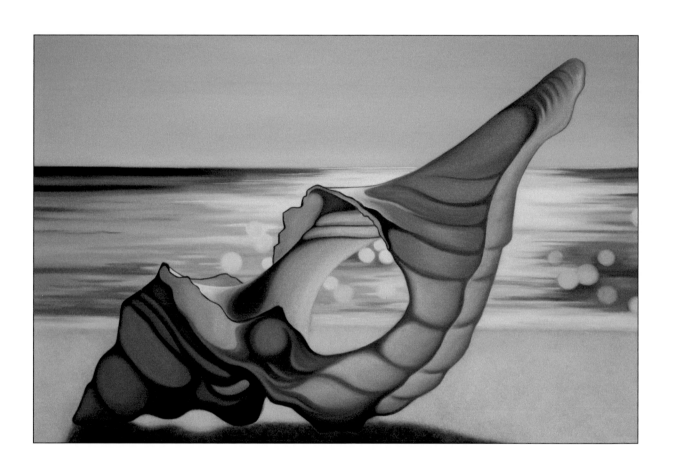

Once one has experienced this deep, abiding joy
A longing develops.
A constant longing.

It is as though one is living in a space
And all around this massive dome
Is darkness.
And far off in the distance is a light.

We live our life,
Day in and day out
Existing.
And the distant light persists.
Permeating the surrounding darkness
Far off in the distance.

Then our greatest desire becomes
A desire to be a part of that light.
To be At One with it.

Yet we know instinctively
We cannot walk to this light.

It is not of the physical.
Yet, it is everything.

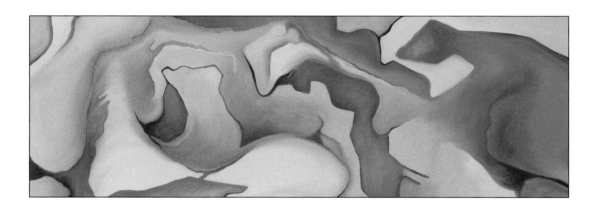

Why does one sink
to such a deep despair...
But to once again rise
to the heights of a soulful joy?
And should one not know
this deep despair...
Does one then know
true beauty and deep joy?

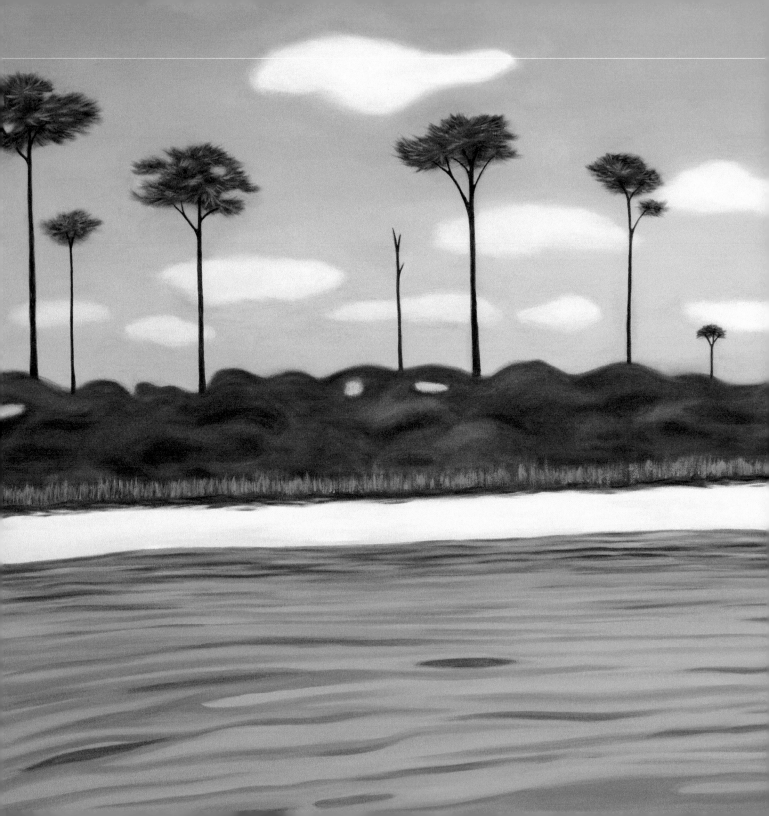

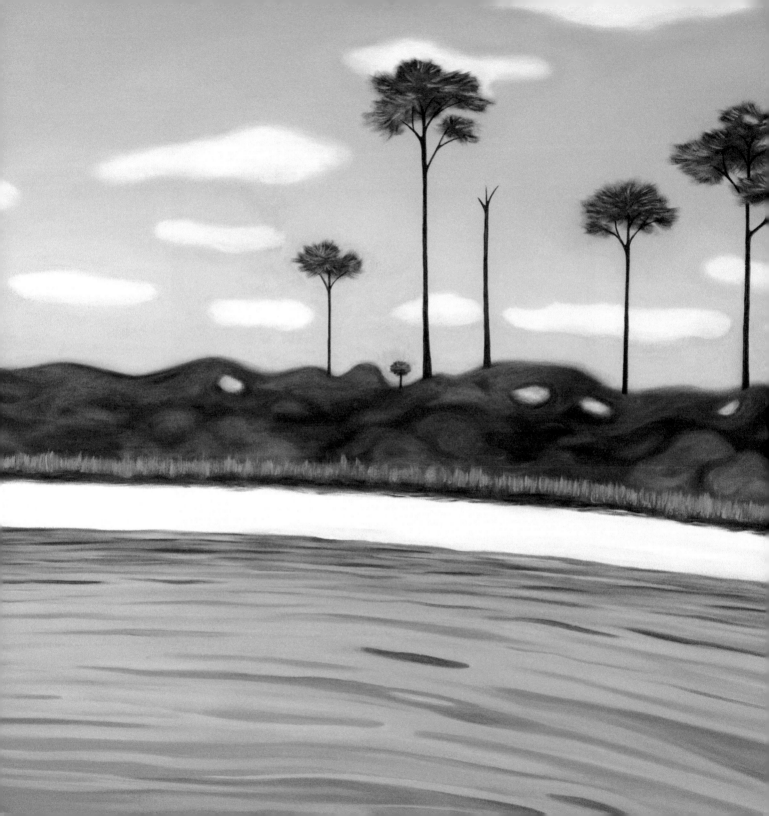

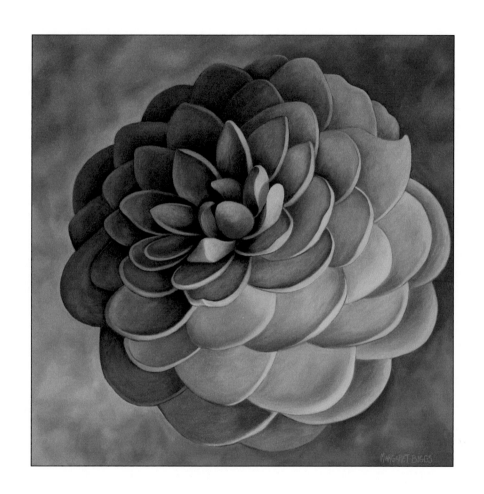

Caged in by fear, a lack of love
The wrong place, profession and mate.
A lonely dove in an enclosed space
A beauty and love displaced.

A lesson taught to put others first,
Their needs more important than mine.
But what of the love of self I ask?
Where else does one find the Divine?

Why do people say things
that don't need to be said?
Why do they give it away?
There is no need.
Mistakes were made.
A thousand shades of gray.

The fight has been fought.
The door is closed.
The time that was is now done.
We have moved on.
For all life is still good,
a struggle, though no one has won.

Perhaps it is true.
Pain I have caused.
Though haven't you done the same?
You open the wound,
My heart bleeds again.
For this, what has been gained?

What is forgiveness
but to live and let live,
Letting past hurts fade away?
To think no more
Of the pain one has caused,
To continue to give come what may.

Thinking back, I know
that I've done the same
to those that love me and are there.
And I ask for the strength
To do it no more,
A cross I'll continue to bear.

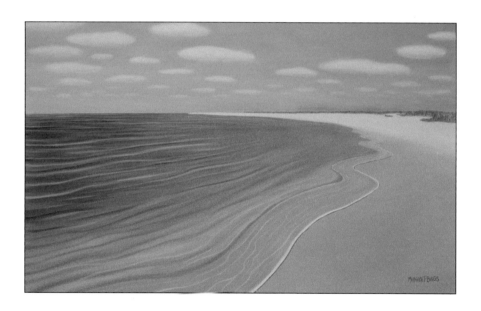

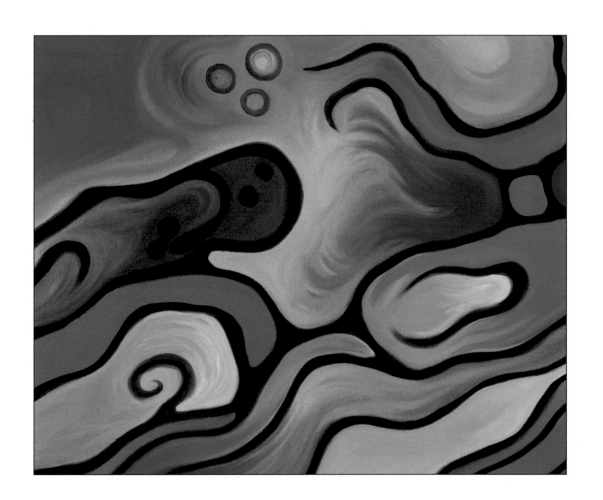

There is no escaping yourself.

Do you have the courage
To look inside?
Deeply
Patiently
Consistently?

Pointing the finger is easy.

Yet if we are honest
No matter how pure our intent may be
We know it always takes two.

You and me.
Him and her.
Their way and ours.
From the one on one
To the thousands.

And who are we to judge?

Do you have the courage
To step outside yourself
Long enough to contemplate
Another view?

Long enough to see
The many flaws we as humans hold
Ever evolving on this temporary plane of existence?

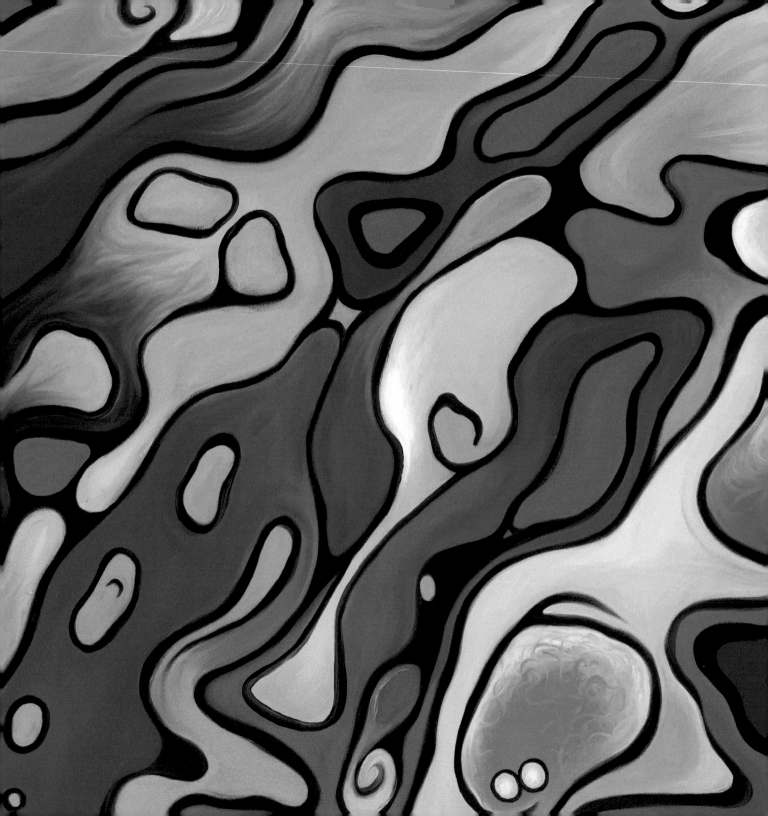

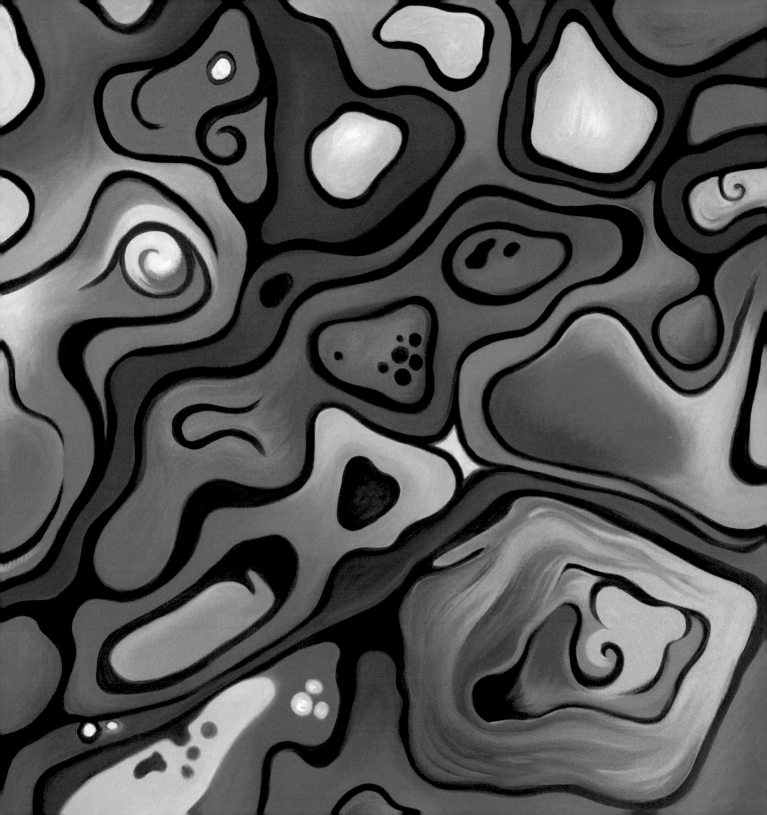

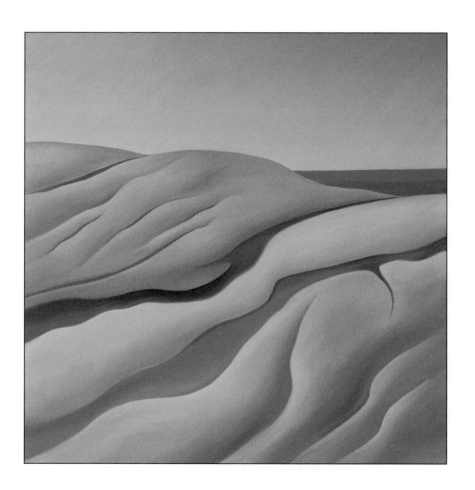

It is a wondrous thing...
The result of shedding
The many layers of the ego.
All the illusions
Of who we think we are.
All the possessions
Of what we think we need.
An attempt to fill an inner void
Of which no thing
No label
No individual
No title
Can fill.
And when one day we find
The possessions
The labels
The friends
The titles...
Have nothing to do with who we really are,
It is then we have the opportunity
To grow from who we have always been
To the manifestation
Of all we can be.

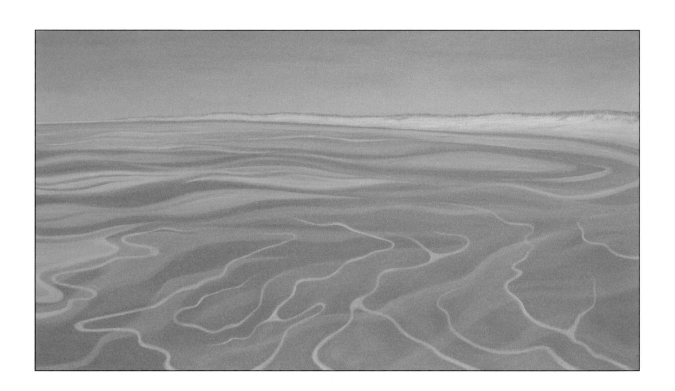

On the Surface of the Sea
Light reflects
The blue of the sky
The clouds just below
The brilliance of the Heavens.
In an expanse of Light
drifting and dancing
radiating
and blessing.
Upwards and outwards
Sharing with the Universe
The Light that is reflected
On the Surface of the Sea.

Yet on the Sea floor
Light refracts.
Through the body of water
To the sand below
The brilliance of the Heavens
Is minimized to lines.
Distorted, bending
Intersecting
And reaching
In one dimension.
Light meant for Infinity
Is limited and oppressed
Far below, on the Sea floor.

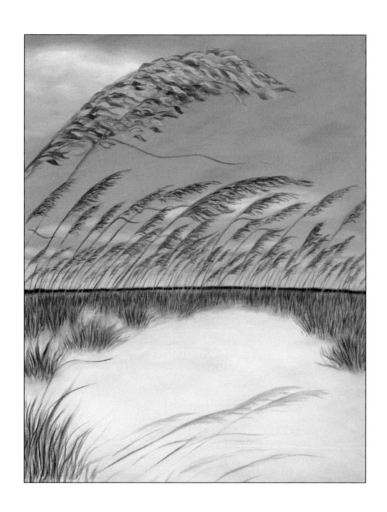

I do not feel old
I do not feel poor
Though there are many who would say I am both.

I am rich in love
Though I am alone.
I am surrounded by beauty
Though possessions are scarce.

I am wiser.
My needs are few.
Grounded in the now
All anxieties cease.

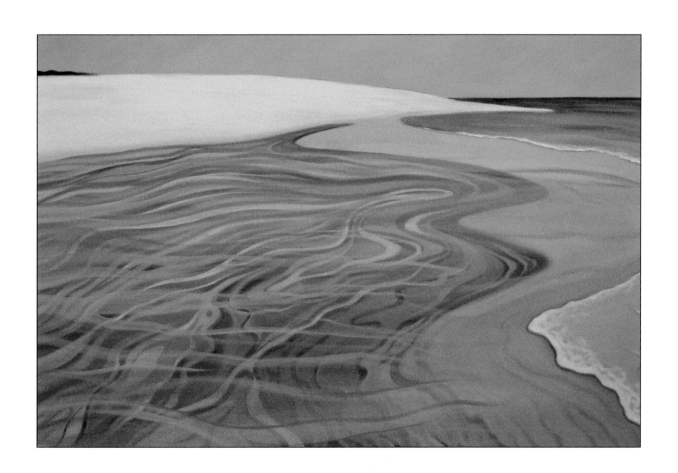

Love is the answer to our prayers long lasting,
It heals and calms and eases human woe.
To love is to look deep within ungrasping,
To find a strength and peace, the constant flow.

The stream within sustains us everlasting
A river rich within most do not know.
To tap this source is to live life unwanting,
Content with how things are so we may grow.

Grow in the love existing without passion,
A love of God and self so we may sow
The seeds of love around us our rendition,
The only means to fend off our heart's foe.

This force resides within us never yielding,
If only we could feel and hear and know.
Glimpses come and go, yet for sustaining,
A discipline and practice that we may row.

Row on a sturdy boat this rich river,
With strength, control and focus deep within
The reward of which a joy from the One Giver
Of which there is no other gift akin.

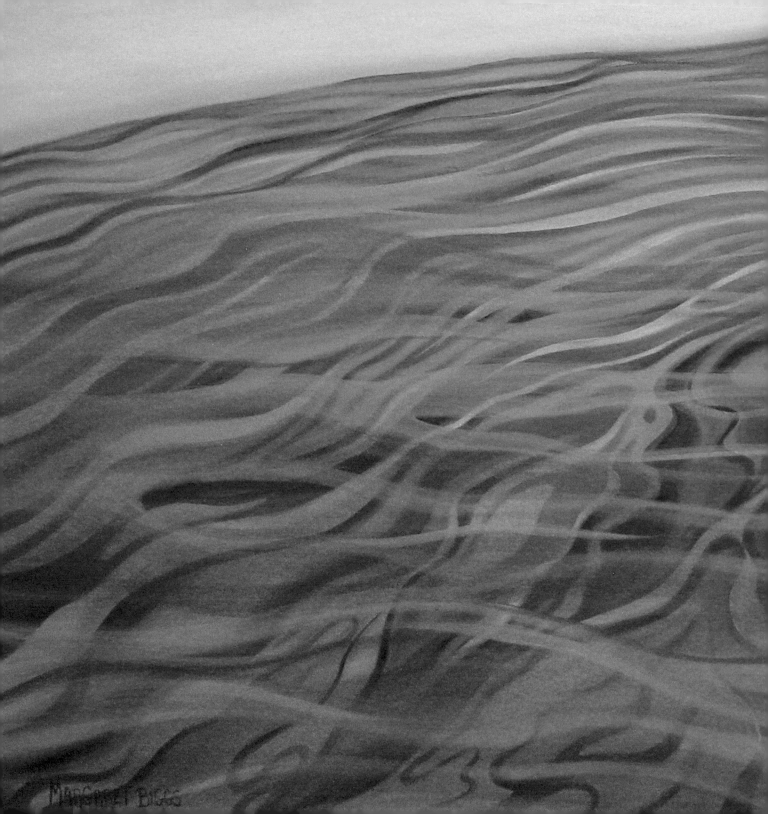

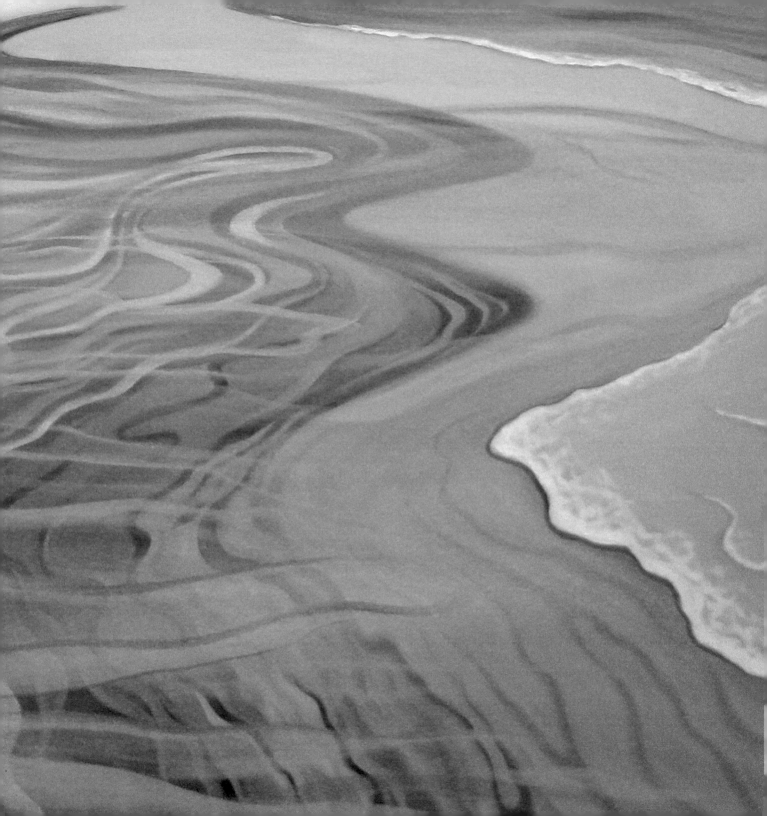

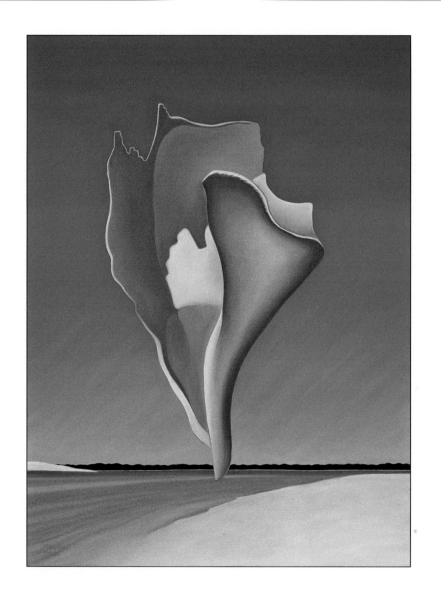

I am a Shell
A Shell of who I once was,
A Shell of who I will become,
Worn smooth with time.
Beautiful from experience.
Broken yet whole.
Deep in my body,
Singing the song of the Ocean
When I am still and all is quiet
And I listen.

A Bliss

There is laughter now
In this modest home.
Simple pleasures abound
As they always have
Yet now they are cherished.

There is a hope for the future.
A confidence.
When before the future did not exist,
In my mind.

There was today and yesterday
Nothing more.
A paralysis.
A void.
No concept of tomorrow.
I dared not venture there.

The days I awake with joy
Are multiplied
In this modest home
With no one beside me.

There is contentment
An acceptance.
A peace.

Beyond all reasoning of the mind
I have been lifted
Far above earthly pleasures
To an eternal bliss.

Now to sustain.

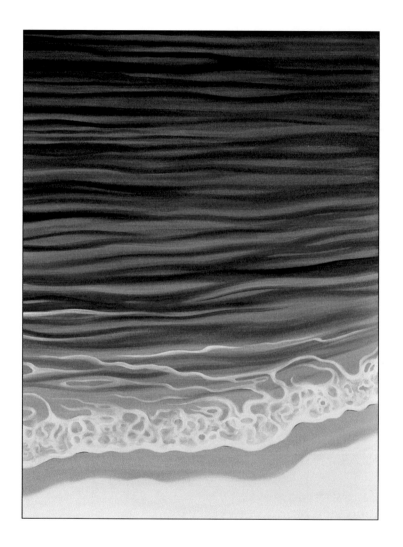

I will give myself to the Sea
As She
Has given so much to me.

A myriad though we are One
Submerge
Bask in the light of His sun.

A freedom, a faith, a release
Rest
In the Heart of One's peace.

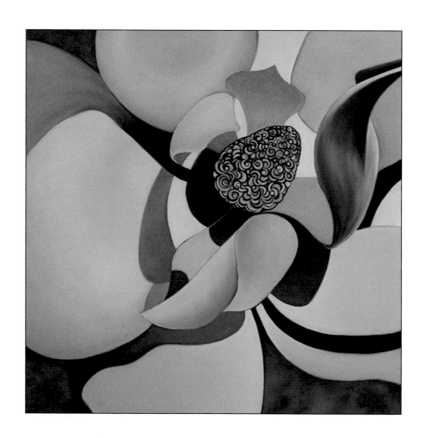

Painting Index

About the Artist

Margaret is a painter, writer and poet.
After decades away,
she has returned to Northwest Florida
where she has found healing and peace.
Through her work, Margaret hopes to raise awareness
of the natural beauty found in the Coastal South
and to aid people in finding inner peace.

Margaret's stylized imagery is known for its peaceful and calming effect on the viewer.
She has an ability to drop deeply into the painting process, which results in a
mystical quality to her work. It is during this process that the poetry
is most often inspired, creating a close correlation between the two.
Her healing poetry and paintings "sooth the soul."

Printed in the United States
By Bookmasters